IMAGES
of America

SOULARD
ST. LOUIS

This artist's rendition of Soulard was made in the mid-1800s.

IMAGES
of America

SOULARD
ST. LOUIS

Albert Montesi and Richard Deposki

ARCADIA

Copyright © 2000 by Albert Montesi and Richard Deposki.
ISBN 0-7385-0717-2

Published by Arcadia Publishing,
an imprint of Tempus Publishing, Inc.
3047 N. Lincoln Ave, Suite 410
Chicago, IL 60657

Printed in Great Britain.

Library of Congress Catalog Card Number: 00-102917

For all general information contact Arcadia Publishing at:
Telephone 843-853-2070
Fax 843-853-0044
E-Mail sales@arcadiapublishing.com

For customer service and orders:
Toll-Free 1-888-313-2665

Visit us on the internet at http://www.arcadiaimages.com

Contents

Acknowledgments 6

Introduction 7

1. Beginnings 9

2. The Great Cyclone of 1896 15

3. Early Life in Soulard 23

4. Growing up in Soulard 37

5. Notable Houses 45

6. Major Churches in Soulard 59

7. Schools 77

8. Streets and Places of Interest 91

9. Industries and Institutions 111

10. Music, Holidays, and Lines to the Future 123

Bibliography 128

We would like much to thank the following persons and institutions
that provided such great help in the making of this book:

David Beecher, Mark Barhorst, Vincent Hromadka III,
Dennis R. Rathert, Rev. Father Radomir, Bonita Leiber (The Framery),
Joan Long (The Abbey), Skip Gatermann, Francis Slay Sr.,
The Sisters of the Notre Dame, Norman Schlagenhauf III,
Vincent's 12th Street Market, the Arsenal, Joe Holman, William Hanser,
Saint Louis Public Schools Record Center/Archives, Lemp Brewery,
Tim Salles, Jim Holloran, and the Mercantile Library.

Introduction

Let us assume that there are angels. With one such, we could easily be transported to the highest point in a neighborhood that appears more European than Midwestern. From this high point, atop the grand spire of the graceful German Gothic Church, we can very well survey the whole of the quaint district that lies before us. Bordered on the east by the wide Mississippi and enclosed from various other sections of south St. Louis, this unique enclave—known first as old Frenchtown and later as Soulard—became the center of immigrant life in the middle and late 19th century.

From 1830 to 1890, hordes of Europeans made their way to the new world to escape ill fortune either in the forms of military conscription, religious repression, or wide-spread poverty. Attracted to St. Louis by the praise of various travel books, by word of mouth, and by the great industrial growth of the city in the middle century, Germans, Serbs, Czechs, Bohemians, Hungarians, Irish, and Italians poured into the city in record numbers. In time they massed themselves in Soulard to such a degree that the area became the most densely populated in the entire city.

Although the section was originally cultivated by the French, who built various graceful farm-estates, it now became a beehive of immigrant houses. However, these newcomers with very little to start with took gradual steps to better themselves. With the aid of their ethnic churches and welfare associations, they managed to scratch out a living as cheaply as possible. Fortunately, many of them were skilled tradesmen who were soon engaged in the industrial trades in the city and in building homes in Soulard.

They built their simple row houses close together to escape the cold, their "flounder" or half-houses to avoid paying full taxes, and their primitive stone alley houses to avoid great costs. Shops of all sorts sprouted to service this horde of residents; the stores were usually built on street corners, and sold everything from groceries to shoe strings. Everything that was needed could be had by walking directly to it. To further service their taste for beer, dozens of breweries grew up in the Soulard area; the most important of these were the Busch, Lemp, and Falstaff breweries. Of these three, only Anheuser-Busch remains active today, the largest and most famous brewery on the planet.

These brewmasters, having grown enormously rich, built lavish town and summer houses, regal gardens, and well-paved streets. In time, the immigrants, climbing up by sheer endurance, entered the middle class and built free-standing, cheaper houses that nonetheless aped their rich neighbors.

Then an event occurred of cataclysmic proportions. In 1896, without so much as a slight prelude, a vast cyclone tore through St. Louis—a storm so fierce that it destroyed a great deal of the Soulard community. Houses were leveled, streets torn asunder, and even the popular market suffered heavy damages. Not to be daunted, the Soulard citizens quietly went about rebuilding their community without so much as any financial aid from the city government.

However, as the neighborhood entered the 20th century, the district underwent a strange transformation. Once an area busy with scores of people moving about, it became one of decline and desolation. Property became vandalized and forsaken. Businesses began to leave the area. There was little new construction of any sort. By degrees, Soulard became a ghetto, inhabited by the poor who were unable to leave it and a horde of rural newcomers from the American South who came there because of the inexpensive rent. Added to these sorry conditions was the vast migration of the original groups who had previously lived there. Their thought was to get out of Soulard as soon as you could. The area was not only an undesirable address but was fast becoming a slum.

In 1945, Soulard was in such decay and decline that various reports were published that proposed that the area, like its nearby neighbor Lafayette Square, should be demolished; its fine buildings razed to the ground. Added to this disturbing attitude was the work of city engineers who hacked away at the area to build its super highways, and in doing so shoveled away some of the most desirable historic property in the city.

Luckily, after World War II, St. Louis began to realize that its glory was chiefly centered in its past. Groups of conservationists became determined to preserve some of the fine old buildings that made up the city's heritage. Of course, Soulard was their most memorable candidate. Dozens of hardy folk came to the area with a determination to maintain and restore some of its ancient charm. They formed the Soulard Restoration Group in 1974, whose sole aim was to restore the soul of Soulard. In that same year, conservationalists were instrumental in having the area declared a historic district. There would be no more tearing down nor vandalizing of buildings in the district.

As time went by, Soulard underwent another sort of transformation—it became the center of a great deal of renewal. Houses were rehabbed, small public parks were created, house tours were conducted, and flowers and trees were planted everywhere. Bars and restaurants were opened to serve hordes of people who came seeking good food and music. By degrees, holiday festivals were inaugurated, and in time Soulard's Mardi Gras became the second largest event in the city's social calender. It has been a long road, but area has finally come full circle. The soul of Soulard has been restored.

One
BEGINNINGS

This is an early view of the Soulard area, c. 1878, which roughly sketches the famed vegetable market and the size and shape of the community that surrounds it.

An aerial perspective of Soulard with the nearby city skyline, looking northward toward the St. Louis arch from a fixed point in the Soulard area, provides us with an overall glimpse of a locale that has remained principally unchanged since the mid-19th century.

In 1842, Julia Soulard, the widow of surveyor Antoine Soulard, bequeathed the city of St. Louis a plot of land that eventually became an enormous vegetable market. Called Soulard Market after its benefactor, this quasi-open structure eventually became a landmark in the city. Not only has the market given the Soulard community its name, it has also managed to survive in all of its vitality to this very day. However long before any building was erected for the market, local farmers (shown here) formed a horse ring around the site from which they hawked their wares from nearby wagons.

As this early picture postcard will attest, Soulard Market became a scene of great activity during the weekends. Here we see the bustling crowd of buggies, farmers, horses, and hordes of buyers moving in all directions on a Saturday morning.

Here we get another view of the crowds who came to the market at its busiest hours. Farmers brought their wagons to the market as early as 3 a.m., while the first crowds usually arrived around six. At ten, as seen above, the market swelled with all sorts of buyers who came to it from all over the city.

After acquiring the land, the city built various buildings to house the popular market. In 1896, these structures were badly damaged by the great cyclone that swept through the city. The handsome structure shown here, patterned after a Florentine foundling hospital designed by Filippo Brunelleschi, was erected by the city in 1924 to serve the market.

This is the east wing of the market as it appears today. The building is shaped by four such wings with its opulent south entrance facing a greensward and a park.

Like its customers of yesteryear, today's market is flooded with weekend shoppers generally seeking the fresh produce of farmers.

Each seller, whose booth may have been licensed by his father and even his grandfather, usually piles up produce in a decorative manner.

A highlight of the present market is the sponsoring a noted local chef on Saturday mornings. The chef creates a favorite vegetable dish with fresh items taken from the morning stalls and skillfully sets forth the food before an eager audience.

Two
THE GREAT CYCLONE OF 1896

In May 1896, St Louis was visited by a howling nightmare—the great tornado of '96. Killing thousands while throwing buildings in the air as if they were match sticks, the black storm also hit Soulard with all its fury. Here we have its path mapped out for us as it hop-jumped from Compton Heights, to Lafayette Square, and finally, to Soulard itself.

The Annunciation Church at Sixth and Lafayette was pulverized by the storm when it swept through Soulard.

Trinity Church took a mighty blow from the storm—half of its major building was destroyed, and the top half of its steeple was toppled. At the time, the Lutheran church was located at Eighth and Lafayette.

Engine House #7 at Rutger and 18th Street was razed to the ground. When needed the most, many public services were knocked out of existence.

Another disastrous flattening, as this picture so dramatically shows, was the George Plant Milling Company at Main and Chouteau.

Thirteen bodies were taken from this death trap at the southeast corner of Seventh and Rutger Streets.

Another calamity was the United Elevator Company on Chouteau Avenue. In the background is a demolished club building.

People walk about aimlessly in yet another tragic scene of destruction, trying to assess the damage done to a house at Seventh and Rutger. Four people lost their lives here.

This is further evidence of the breakdown of all services in the distressed area: the Power House People's cable railway lies tossed over, its structure dismembered.

The northwest corner of Broadway and Barry was the site of another tragic scene.

Similar destruction can be seen directly across the street at the southeast corner of the same intersection.

More destruction is apparent at Broadway near Miller Street.

Pictured is a train of Southern Electric Railroad as it lies derailed and crippled. Its motorman and conductor were both killed.

Still further damage is visible at the southeast corner of Seventh and Park Avenue.

Broadway and Soulard Street were not spared from the decimation.

Three
EARLY LIFE IN SOULARD

Before and after the Civil War, St. Louis flourished. It soon became the most important river port on the Mississippi and a busy industrial hub. As we have indicated, its population soared as thousands of immigrants poured into the city seeking work and a new life. Hundreds of these immigrants settled in the Soulard area, then known principally as Frenchtown.

Still standing, this image is an example of the sort of house struggling immigrants built on their arrival in Soulard. Patterned roughly after European models, the dwellings were constructed directly off the front sidewalk, placed in a row, and entered by an arched gangway or "mouse hole." The address is South Broadway, one of the major streets then and now in Soulard.

In order to build as cheaply as possible, immigrants sometimes erected simple stone houses in alleys behind larger residences. Here is one such "alley house" near Eighth and Allen.

When they were prosperous enough, Soulard newcomers sometimes built free-standing pitched roof affairs. Here is one such early dwelling still standing on Lemp near the Busch Brewery.

This is another instance of a single, free-standing early cottage that has undergone an amazing transformation. The rehabbing and renewal have resulted in a very attractive building. It stands near one of the few public parks in Soulard—the popular Pontiac Park.

Two- and three-story family dwellings with entrances to the flats from the back stairwells were among the first buildings constructed in the area.

Here is a cameo of urban life in Soulard in the mid-19th century. Two ladies are walking near Eighth Street and Soulard Street dressed, perhaps, for a late afternoon shopping tour.

Pictured is a house that appears to have been converted from a corner shop into a cozy home. Several houses in the district have been reshaped in this manner.

At this LaSalle Park area at 1319 Ninth Street, one encounters another characteristic of the building trade of that era—peeping out from a sturdy stone building are the windows of the basement section, aligned with the street.

Half-houses—or "flounder houses" as they were called, since they were said to resemble the fish—were built to avoid full taxes. This one, which faces Pontiac Park, has a veranda porch added to its thinness.

Notice the utilization of the back stairwells, side porches, verandas, and flounder houses in the following series of pictures—such devices characterized the architecture of the day. In the above image, a staircase and veranda gallery have been attached to a large commercial building of the times. These porches were not solely applied to residences but to businesses as well.

Across from Pontiac Park at Ninth and Shenandoah, we observe the constant renovation that is going on in the Soulard district. This image reveals another old single-family house being carefully rehabbed.

Vincent's Market is a long-standing grocery store on Twelfth Street. The grandfather of the present owner of stands proudly in front of his store.

Soda fountains featured magic treats made from a recent invention—ice cream. They were favorite places to hang out, as this image of a group of Soulard folk at a local fountain indicates.

Here is one of the first motor garages in Soulard whose business was to tend the new horseless carriages . . . Gasoline Alley, indeed.

These "babes in arms" are carefully outfitted in the proper tiny tot clothes of their day.

This 1910 family portrait at 715 Shenandoah was probably shot by a roving photographer looking to earn a bit of cash with his camera.

A fond owner pauses for a photograph with his horse. Moments like this slowly disappeared from the streets of Soulard.

Photographs of mothers and their children have always been popular.

Two-and-a-half-year-old Angela Gaska was very serious about being photographed in 1916.

33

Three grinning Soulard buddies share a moment.

This house at 2210 Tenth Street, across from Pontiac Park, is evidence of the continual renovation that occurs in Soulard day by day. One can readily detect what innovations have taken place here, particularly the new porch. This house is particularly old, dating from before the Civil War.

Pictured is another old dwelling that harks back to the early days of Soulard.

Built directly to the sidewalk and without front doors, this house is characteristic of an immigrant home.

This house that has been partially renovated. In order to imitate the open veranda porches of the past, the owner has re-created such a porch on the side of the house.

Four
GROWING UP IN SOULARD

In order to achieve a closer look at a certain period in Soulard life, we managed to obtain a series of photos of a young lady. Our subject, Miss Caroline Wooldridge, was born and raised in the neighborhood during the early 1920s.

Here is a photo of Caroline's family: her mother (front, right), father, and aunts before her birth.

This 1914 photo depicts our young infant with her father, Henry, and her mother, Pauline.

Caroline poses here on a blanket with her two cousins, Adele and Leroy, in the background.

Here is our very young lady as she appears with her mother in a "Madonna and Child" genre picture of the day.

Our subject as she appears at age four and a half in front of her home at Fourth and St. George in Soulard.

Taken at the same address on Fourth, this image shows Caroline at the age of five.

Here is Caroline with her many cousins in 1918 at Fourth and St. George in a Soulard gathering.

Set again at Fourth and St. George, Caroline is shown here with her many cousins: Lucille, Adele, Leona, Harry, and Leroy.

Caroline, about age 11, is pictured on the third floor of her 1700 South Broadway home. It is Easter morning and the little girl is festivally attired.

Caroline (second back row, second from the right) poses with her eighth grade class at Shepard School in 1928.

Here again is our subject (fifth from the left, sitting on brick) with her class at Shepard School.

43

Caroline is all dressed up for her graduation from Shepard School in this 1928 picture.

Caroline's stepmother Gertrude (far left) with her friends—the last generation to truly represent the Soulard experience. The picture was taken in the mid-1950s.

44

Five
NOTABLE HOUSES

In contrast to the simple inexpensive houses that the immigrants erected stood the opulent homes of the rich of the Soulard community. Chief among these were the dwellings of the brew barons, whose wealth had become astronomical for the day. At one time there were 40 breweries in the neighborhood, for the enormous German population in Soulard had to have their beer. As we glance at the pictures that follow, it is worth noting that restoration has occurred with expensive as well as inexpensive houses.

The majestic DeMenil home has survived many attempts to level it to the ground in its long, turbulent history. When I-44 was constructed, it was destined to be dismantled. Certain conservationists rose in protest, and—having already once protected it—began an excellent program to restore it. The present restoration is a credit to its saviors. It is one of the most graceful structures in the city.

Pictured here is the rear of the gracious DeMenil mansion, demonstrating the care that was taken to restore every feature of the original arrangement that the manor house once enjoyed.

Two views of the famed Fuerbacher mansion, with two massive stone lions fiercely guarding the entrance. This imposing structure, also known as "The Famous Lion House," was built by beer baron Anton Fuerbacher.

Here is a closer look at the Lion House at Twelfth and Sydney.

The famous Artz house, at 2322 South Twelfth Street, was so much ahead of its time that it contained a hot water heating system, a cooling system, and a greenhouse.

The front entrance to the Artz house was built by Artz, a prominent South Side physician. The mansion's entrance depicts a characteristic up-scale stone fence and the popular iron gate.

The physician made his office in a dwelling that he built behind his Italianate villa.

The famed Lemp mansion was better known for its ghosts than its beauty. This amazing house was the home of the Lemps, a rich brewer family whose spirits are said to still roam the house. It contained, among other conveniences, a theatre in its underground cave.

The pitched roof of this semi-Federal-style mansion was typical of the era. Many of these affluent homes were built with Mansard-style roofs, but early pitched roofs also remained popular.

One of the "musts" of the wealthy lifestyle was, of course, the fine buildings in which they kept their carriages. This carriage house, which is still standing, is in the rear of a home at Twelfth Street and Shenadoah.

Pictured is an early house displaying modesty in its simple elegance.

This structure, a striking example of the Second Empire architectural style, has the high windows and doors, the Mansard-roofed third floor, and the cornice details associated with this popular style.

This home at 2333 South Twelfth Street is a mixed bag of Richardsonian and other styles. Its cupolas and Queen Anne towers make it an Germanic Gothic hybrid.

Here is another Richardsonian house with heavy, forbidding brick that provides a tone of stability and authority, more utilitarian than esthetic.

The mansion at Twelfth and Lami is surely the Richardsonian style at its best. With its rounded arches, bays, and towers, it remains the top house of its type in the district.

As we can detect from the renovations of this house, it appears to have been divided into separate apartments. This frequently occurs in present-day Soulard; old homes are sectioned off into various households.

Here is another house of moderate means that captures some of the features of its more opulent neighbors.

In the following section, we will be comparing the restoration done on two houses: one originally constructed for an affluent owner and the other a far simpler affair. In one house, owned by Skip Gatermann at 2310 South Twelfth Street, we see the amazing transformation of a simple home. The other, at 2314 South Twelfth Street, is owned by Stephenie and Will Zorn. Our goal here is to demonstrate that any structure in the Soulard area is worthy of renovation.

Pictured above are the two types of houses in question, one smaller and simpler, the other taller and more elegant.

This is the living room of the simple house at 2310, provided with an excellent array of period pieces.

An array of proper antiques and other ancient adornments appear in the bedroom at the 2310 South Twelfth Street home.

A display of old photos and memorabilia adorn the dining room of 2310.

This cornice of the home at 2314 is unusual because it is made of double metal. Its presence is enhanced by a painted coloration that resembles the "painted ladies" of San Francisco.

The elegant front parlor of the 2314 South Twelfth Street home contains one of the house's six marbleized fireplaces.

Pictured is the game room at 2314 with its handsome back wood paneling.

The staircase at 2314 is made of elegant walnut. It runs from the first to the third floor.

Six
MAJOR CHURCHES IN SOULARD

One of the ways immigrants maintained ties to their homeland was through their churches. Not only were churches cultural bastions, but in many cases, they provided financial and psychological aid to immigrants through clubs and organizations.

Attracted by a book glorifying the St. Louis area, Germans poured into St. Louis by the hundreds, settling by the score in the Soulard area. Depicted is the Trinity Lutheran Church and its school in 1910, a church founded by pilgrims fleeing religious pressures in Saxony.

Here is a full view of Trinity Lutheran as it exists today.

A choir of Trinity Lutheran parishioners gathers for a group photograph.

One of the major attractions in the Soulard area is the Ninth Street Abbey—a church turned restaurant by the vivacious Joan Long and her husband. Atmospherically and culinarily, the Abbey is one of the most gracious venues in the city, and hundreds come to it for good food and its grand hospitality.

The Abbey had its beginnings as St. Paul Church. It later became the Holy Trinity Slovak Catholic Church. Here is a photograph of the highly festive and generously decorated celebration of its 75th anniversary. Much later, the church was vacated; it remained deserted until Joan Long worked her own kind of magic upon it.

Doting the various stairs of the Ninth Street Abbey are photographs of young couples in their wedding finery who married at Holy Trinity early in the 20th century. The young bride in this image featured flowers streaming from her hair.

Here is another picture from the Holy Trinity collection at the Abbey. This time we are provided with a view of a whole wedding party.

Although many years have passed since this image was initially taken, the young bride remains very attractive in her then-fashionable garb.

Pictured is yet another glance at a period wedding party.

Built by the Lebanese in the tradition of the Syriac Maronite Church, the Old Church of St. Raymond's was erected by them when they first came to Soulard. This structure was torn down when a housing project was erected on its site.

Today's St. Raymond's stands in all of its golden-domed splendor near Ralston Purina's Checkerboard Square.

64

This religious play was performed to honor an ecclesiastical dignitary at St. Raymond's with parishioners in ethnic costumes.

Here, again at St Raymond's, is a 1920 photo of a priest with parents and a baby child in what must have been a baptismal celebration.

Another church with ancient roots is the Holy Trinity Serbian Eastern Orthodox Church, which stands at 1910 McNair.

King Peter II of Yugoslavia (with glasses) is pictured here on his one visit to the Holy Trinity Serbian Eastern Orthodox Church. This was an event of extreme significance as indicated by the size of the crowd that welcomed his coming.

St. Stephen's House, at Sixth and Rutger, was an Episcopal mission church. It is shown here on a penny postcard in 1910.

Perhaps the most outstanding church in Soulard is Sts. Peter and Paul, shown here in a 1910 postcard view. Towering over the district with its spires and towers, the church not only defines the area, but provides it with a sense of awe.

67

Another shot of the German Gothic Peter and Paul reveals its elaborate apse and buttresses. The original German church on the Geyer site was destroyed in the Great St. Louis fire of 1849.

A contemporary shot of Peter and Paul emphasizing its limestone exterior painted black and white, and its giant steeple that keeps careful watch over the area.

Originally St. Lucas Lutheran Slovak Church at Gravois and Allen, this holy structure was known later as the Harvest Church.

Pictured here is St. Agnes Church in 1910.

This 1910 postcard depicts the Jesus Evangelical Church. This attractive building later became the United Church of Christ, and is still located at 1115 Victor.

St. Vincent de Paul, one of the earliest churches built in the area, is well known for its charities and help to the indigent of the city.

St. Mary of Victories, at 744 Third Street at Gratiot, opened in 1844 and is said to be the second oldest Catholic church in St. Louis.

St. Joseph's Croatian Church, at Twelfth and Russell, was purchased by Soulard Croatians in 1925. It has since been renovated several times to become the handsome structure that it is today.

This image of St. Joseph's provides us with a more detailed view of the gracious complex.

St. John Nepomuk is the first Czech church in America, and the first anywhere outside of Bohemia. It became the center of an area inhabited by Eastern European immigrants called Bohemian Hill.

St. Agatha, an immigrant Catholic church at Ninth and Utah, celebrated its 125th anniversary in 1996.

St. Marcus was originally known as the South German Evangelical Church, having moved to its present site, at Russell and McNair, in 1915. The parish recently opened a theatre on its grounds—a venue that has attracted many St. Louisans to return to the Soulard area.

This early church, erected in 1871 at 2838 Salena, once called the Church of the Good Shepherd, has now been converted to a private home.

This attractive, if unusually styled, church provides an immediate aesthetic response. It is located at Twelfth and Sydney and is currently called the Open Door Reach Ministries.

St. Michael's Orthodox Church, located at 1901 Anne Street, was established in 1906 by immigrants from Austria-Hungary and old Russia.

Seven
SCHOOLS

As we have indicated, the first schools erected in Soulard were both public and private institutions. The private schools were attached to some church or denomination. As time went on, impressive, well-equipped public schools began to dot the cityscape. These superior schools soon tended to eliminate the need for religious ones. The school buildings, as the following items will readily illustrate, were in no way inferior affairs. Some of these, like McKinley High School, were built with grace and authority in mind.

The handsome McKinley High is shown here in 1910.

McKinley High students were encouraged to develop their practical skills as well as their academic ones. Here we observe a group of students in a forge shop in 1926.

As this December 1936 photo will attest, the McKinley High play was not some worst kind of amateurism, but rather, it was presented with an air of sophistication and professionalism.

As for science, the students did not suffer from ill-equipped labs. Here is a biology lab that looks entirely up-to-date.

The Sigel School, pictured and founded in 1910 at 2050 Allen, was named after a German general who fought for the Union during the Civil War and who sometimes gave his German recruits orders in German.

This photo of Sigel School was taken in 1953.

Here the first grade students of Sigel School are being instructed in their first attempts at "sentence writing."

This 1911 image shows a gathering of Sunday school students at the Markham Church at Menard and Julia Streets in the early days of Soulard.

A flyer or postcard created by the Markham Church in 1910 was issued to induce youngsters to come to their Sunday school.

Students at Madison School were busy eating lunch when an enterprising photographer took this picture in January 1931.

This picture, dated 1945, shows a boy and a girl reading within Madison School.

Lafayette School kindergarten celebrates its "Frontiersman Day" in this November 1930 image.

Mt. Pleasant pre-school little folk play in the sun on the school's roof.

The Pestalozzi School, with its avant-garde instruction in children's education, had a celebrated rhythm band made up of young students.

This image, dated May 1943, shows the Humboldt School celebrating a "Physical Education Exhibition."

When this photo was taken in 1937, the Pestalozzi School was protected by these so-called "patrol boys" who mostly helped young students over busy streets.

From the Ninth Street Abbey Collection, schoolchildren sit at their desks at the church school connected to the Holy Trinity parish.

These early group pictures were usually taken by professional photographers who were brought in for the occasion

This Abbey Collection picture of a class of children and their teacher is another example of the conventional school photo so popular in this era. At the time, so few cameras were available that pictures such as the above were in great demand.

Another class connected to one of the parish schools is shown here.

The Trinity Lutheran School still stands after all these years.

This is a rare 1898 photo of a class conducted in German at Trinity Lutheran School. Due to the large German population in Soulard, classes were often available in both English and German at this early time.

Pictured is a contemporary shot of the ongoing religious school of St. Agatha.

Eight
STREETS AND PLACES OF INTEREST

Dated 1909–1910, this photo is a long shot of the historical U.S. Arsenal as it borders on the great Mississippi. During the Civil War, with St. Louis passionately divided between Confederate and Union sympathizers, this ordnance depot was saved for the Union through the efforts of Capt. Nathaniel Lyon and his pro-Union regiments.

This 1909–1910 postcard gives us a view of the arsenal after it survived all of the turmoil of the Civil War period.

This view of the arsenal and its several buildings emphasizes the primitive manner in which they were originally built.

On property once donated by the Federal government to St. Louis, Lyon Park—extending directly across from the Arsenal Grounds—was named in honor of General Lyon for his efforts to save the Union. The postcard shown here was dated in 1906.

In honor of General Lyon, a statue erected was featuring him on his favorite horse. Sadly, he was killed in a battle with Confederate forces near Springfield, MO, early in the war.

A stone marker relating details of his life was also erected in honor of the General.

Pontiac Park, the official park of Soulard, has served thousands of children since it was donated to Soulard by the city in 1908.

Pictured is a garden of some beauty at 2333 South Twelfth Street.

This is one of the several public gardens recently established in the area. Put together with hard work and commitment by Soulard volunteers, this gracious small garden is located on Lafayette near Broadway.

Soulard is at its best as a retreat from the frantic city. Here we catch a glance of a tranquil and serene street, flanked by flowering pear trees, all neatly arranged on both sides of the avenue.

At Julia Street near Menard is a century-old line of row houses, all stacked neatly together, still standing after all these years.

In all of its old world charm, the Nepomuk Church holds forth in what promises to be a renewal of Bohemian Hill. The Bohemian Hill, with the church as its center, was once the home to groups of Czech families.

At this house (close right) at Eighth and Soulard, the famed Buffalo Bill once ate Sunday dinner. He later married the home owner's daughter.

This home at Eleventh and Lami (shown on the right) contains two parlors in two of its tall-ceiling rooms. This is considered as an arrangement in "country style."

A neighborhood that was once a part of Soulard, known now as LaSalle Park, stands adjacent to the present ward. Here we see a scene from its almost fantasy-like ambience as we look west on Morrison Avenue—one of the area's most attractive streets.

Ablaze with spring, this is Twelfth Street looking south in the midst of a sunny afternoon.

A remnant of an aristocratic past: a stepping stone by which passengers could step up to a waiting carriage.

This enormous chimney rises from a roof on Eighth and Geyer. It was built in this manner to protect the roof from sparks.

Here at 2414–16 Menard we are able to examine a stable kept by the wealthy Cabanne family with its recent horse-head figure looking down at us.

Here is another view of the stable with its hitching post, ready for use.

What catches our attention is the magnificent ironworks so cunningly crafted here at Tenth and Shenandoah. Most of the ironware came from the Pullis Ironworks, a local foundry.

From a lower angle of vision, we can see a very fanciful balcony made of the ironware from the Simpson foundry, another successful enterprise of the day. Its foundry was located directly off of Soulard Avenue (renamed Lafayette.)

Upon examining this structure, we can readily see the results of rehabbing. This balcony, veranda, and picket fence are all recent additions. Renewal of this sort can be seen all over Soulard.

103

Pictured is another view of the New Orleans-like grillwork that adorns many of these houses.

The grounds of the regal Chatillon-DeMenil mansion included a garden gazebo, as seen in the background. The gazebo, a favorite structure of the Victorians, adorned the yard of many of these elaborate Soulard homes.

Nearby, the grounds of the Lemp estate featured both its Queen Anne tower and a larger, more opulent gazebo than that of the DeMenil home.

Here again we see evidence of how the newcomers have set about gentrifying or seeking to improve the area; note the flower box placed in this old home in imitation of the Dutch practice of long ago.

The front entrance to the Venice Cafe Building reflects the features of the past. The paned glass of the front together with the arched entrance are in direct contrast to the frenzied decor of the sixties that adorn the cafe.

The Victorians' fascination with ornate stone fences is apparent in this image. What we see in the symmetrically placed stones and their notched upper fellows is a suggestion of solidarity and durability that the Victorians so passionately sought to display in their furniture and buildings.

The period saw its eclectic fashions spelled out in buildings such as these. The bay area is characteristic of the pre-Civil War era, the Mansard roof of the late 19th century, and the arched windows of the Italian villa. Overall, there is a suggestion of Richardsonian Romanesque. Thus, the higher classes mixed their style.

One must recall that the most utilized source of fuel for this period was the burning of coal. Here we see the coal bin openings in the basement of an ancient home.

Most chuckled over building in the whole of Soulard. The so-called "brick outhouse," which still stands today, was a necessary structure in those days of outdoor privies.

We have spoken often of the flights of stairs that acted as an entrance for the two- and three-storied abodes that the immigrants built. Pictured here is a close-up as to how these stairs were crafted.

Another construction feature of the day was a cast-iron rod that supported the main joist. The star figure ending is a utilitarian feature, not an icon or a secret sign.

A close-up of the so-called "mouse hole" that led finally to the backyard and the back entrance to the piled-up stairs.

Pictured is a view of the Jednota Sokol Hall with the famous "smiley" sign carved into its exterior.

Telocvicna Jednota Sokol Hall began as a gymnasium and a meeting place for Soulard Germans. Later, it was used by the Czechs as a Sokol. Later still, it was sold to the now defunct Smiley Soft Drink Co.

Nine
INDUSTRIES AND INSTITUTIONS

This is a 1910 photo of the Anheuser-Busch family estate that was erected near the brewery. One can see immediately that it was a striking affair with what appears to be a primly, laid-out, private roadway.

This is an early postcard of the mammoth Anheuser-Busch Brewery with its cluster of busy buildings in 1903.

A noted Anheuser-Busch logo (the eagle figure) is pictured here with a watchful eye as if guarding the vast brewery and its buildings.

The Falstaff brewery as it exists today: vacant, idle, and in decline. Once a thriving enterprise with its name known world-wide, it shut its doors decades ago.

Here is another look at the deserted Falstaff Brewery with conveyer tracks leading to a storage area.

The ill-fated Lemp Brewery was once the most successful brewery in St. Louis. Towering over all others, it fell into oblivion as its owners died early by disease or suicide. The giant complex, now deserted and forlorn, will soon be rehabbed by some enterprising investors.

Pictured is another view of the Lemp Brewery with its architectural strength still unchanged.

Breweries were built in the Soulard neighborhood because of the proximity of the river for transportation and because of the vast system of underground caves that were everywhere in the area. Since one could store beer in cool caves, businesses sought property that contained them.

From the once highly utilized Lemp cave came most of the great Lemp fortune. The Lemps had discovered a new ale, called lager beer, that demanded cold temperatures in the hot St. Louis summers. The family soon used the caves for various innovations in their home such as a theatre erected underground and hot and cold running water. The cave also served as a passageway from their home to the brewery.

IN ST. LOUIS, BE SURE TO SEE...

CHEROKEE CAVE
and MUSEUM!

Black Dahlia
The Schmoo

Damascus Palace
(1000 yrs. old)

Pre-Historic Peccary
Found in Cave

OPEN DAILY 10 A.M. TO 10 P.M.
- A Million Year Old Cave In the Heart of St. Louis
- Damascus Palace • Colonial Mansion
- Art Museum • Pre-Historic Bones
- Future Site of Jean Baptiste Roy House (Oldest House in St. Louis)

3400 So. Broadway at Cherokee

Pictured here is an ad announcing the various attractions that were featured in a newly opened cave fully equipped with all sorts of oddities. This so called "Cherokee Cave," put together by entrepreneur Lee Hess, became a museum and an entertainment center for those wishing to explore the caves once used by the Lemps and others.

Spaghetti Room - CHEROKEE CAVE ST. LOUIS, MO.

Among the many attractions presented in the cave was the so-called "Spaghetti Room," whose dripping stalactites resembled coils of spaghetti.

Another appealing exhibition for tourists was the so-called "Black Dahlia" room. Its rock formations seemed to resemble a dark flower.

The most outstanding feature in the caves' contents was the presentation of the so-called "Damascus Room" that was included in the Damascus exhibition in Chicago in 1903 and the St. Louis World Fair in 1904.

Pictured is a a dazzling display of some of the ornaments that the thousand-year-old Damascus palace contained.

This old postcard of City Hospital is dated 1907–1909.

The South Broadway Athletic Gymnasium—an old-style athletic club—still stands today.

Adolphus Meier's Cotton Factory—once the first factory of its kind west of the Mississippi—is being renovated today from top to bottom. In its early days, the factory's grinding work was performed by boys and girls.

The A.E. Schmidt Company was once a factory for the production of billiard tables. This building is in the process of renewal as well, having become the present location of Joan Long's catering service.

Now deserted but once a neighborhood bar, The Pit Stop is another illustration of the so-called European style with its four apartments and entrance doors in both the front and rear.

The Menard Street Mission, formerly the Soulard Market Mission Sunday School, organized as early as 1815. This remarkable building, handsome to the last, has managed to survive the entire Soulard experience.

Once a factory producing baby carriages, the enormous building has been partially taken over by an enterprise selling all sorts of infant furniture and clothes.

Ten
MUSIC, FESTIVALS, AND LINES TO THE FUTURE

Along with Kansas City, St. Louis has witnessed the occasional birth and development of various African-American musical styles such as ragtime, blues, and jazz. With the arrival of a new, revitalized energy, Soulard has emerged as the central St. Louis district for jazz and the blues. Moreover, to add to its new image, it has become known for its celebration of such French holidays as Bastille Day and, of course, its vastly popular Mardi Gras.

Clementine's, pictured here, has long been a mainstay in the Soulard area. Music in this popular bistro is generally provided by jukebox.

One of the most outstanding Irish bars in the country is Soulard's very own McGurk's at Twelfth and Russell. Importing musical talent from Ireland itself, McGurk's has become the entertainment center of Irish social life in the city.

Here at McGurk's, Irish musicians Benny McCarthy (accordion) and Tom Durley (flute) play Irish tunes to festive, drinking audiences.

Again at McGurk's, Irish performer Paul Flynn plays a stomping fiddle to admiring crowds.

Obie's, another corner bar, directly across from the Market, occasionally provides live music for its customers.

The Hard Shell Cafe at 1860 South Ninth Street presents, regularly, various jazz and blues sessions provided by such bands as the River City Blues.

This is the famous Venice Cafe. Decked out here in its sixties garb, the venue attracts musicians, poets, and all who remember that decade with nostalgia and fond memories. Its poetry sessions attract much local talent.

A Mardi Gras poster proclaims the glories of the upcoming event. In imitation of New Orleans, Soulard presents—in a spectacular fashion—its own Mardi Gras each year. There are all sorts of events such as the Mystic Krewe of Barkus Parade, Weiner Dog Derby, Children's Art Parade, Taste of Soulard, Micro-Beer Taste, and other attractions.

With thousands attending, this event has become a stunning success. Here, hundreds of happy folk watch the celebrated Saturday parade.

This Soulard Market sign proudly proclaims to all that it has stood since 1779. It is hoped that it will act as a harbinger of hundreds of more years of Soulard life. It is indeed a reminder that no amount of decline or decay will deter Soulard's spirit to survive.

BIBLIOGRAPHY

Coyle, Elinor Marineau. *Portrait of a River Town*. The Folkestone Press : St. Louis. 1966.
Coyle, Elinor Martineau. *St. Louis Treasures*. The Folkestone Press : St. Louis, Mo. 1986.
Knapp, Joseph G. *The Presence of the Past*. St. Louis University Press. 1979.
Pettus, Robert C. , & Toft, Carolyn Hewes. *St. Louis' LandMarks & Historic Districts*. St. Louis Landmarks, Inc. 1988.
Rodabough, John. *Frenchtown*. Sunrise Publishing Co, Inc. : St. Louis. 1980.
Rother, Hubert and Charlotte. *Lost Caves of St. Louis*. Virginia Publishing Co. 1996.
Soulard Restoration Plan Community Development Commission, Soulard. St. Louis, 1975.
Toft, Carolyn Hewes. *Soulard: the Ethnic Heritage of an Urban Neighborhood*. Heritage, St. Louis. 1975.
Vila, Bob. *Bob Vila's Guide to Historic Homes of the Midwest and Great Plains*. Lintel Press, Wm Morrow : New York. 1994.
Wayman, Norbury L. *History of St. Louis Neighborhoods*. St. Louis Community Development Agency. 1978.